RACHE

Esmé &
Mary 4 Eva
2008

sh bar to open

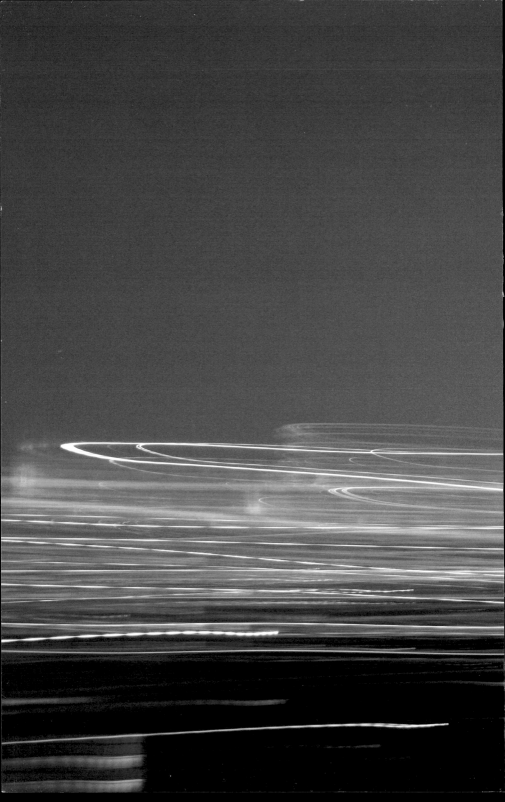

memory colours
gemma seltzer

He's waiting outside the gallery holding an A-Z, thumb marking the page, weathered fingers tapping on the book cover. He steps onto the road, to let a woman in fur pass. When she nods her thanks, he says something in reply and she throws her head back in delight and bares hundreds of teeth.

It's my dad and he's here in London, he made the journey and now he's waiting for me, with a map and an appropriately small bag and he's making someone laugh.

There you are, he says. He kisses me on both cheeks and I think: this is new. He must have seen people do this on television. *It's fine that you were late.*

I'm late? Quietly, I ask this.

Are you hungry? Shall we eat?

Let's try here, I say, leading him inside. There's a step and I feel his body jerk when he lifts his left leg each time. *Are you okay?*

Fine, it's fine. He struggles up three flights of stairs and we find the café.

We order and he finds us a seat. Students in oversized glasses are staring into a laptop screen. The light casts a coloured shade on them and they talk to each other with purple smiles and purple faces.

I tell a story about my boss and a washing up bottle.

I've let the garden grow wild, he says. *Now your mother's gone, I just let it grow.*

It's been three months since we spoke of her.

Really? I thought you loved the garden?

I do love it, he says. I'm happy because my father loves. Even more now. *It's…* He thinks for a moment, he pouts his lips, dandyish. *Sumptuous and reckless*, he says.

That's great, dad.

And how've you been? he says.

I find her in the most unexpected of places, I say.

He nods and pulls out his A-Z. *Show me.*

Outside, his shiny shoes make no noise, whilst mine sound like a ticking clock. We slip down side streets, avoiding those who see daytime Soho through their camera lenses, focusing and refocusing on the red neon lights, the abandoned cardboard boxes, a rotting apple, the exposed wire on a wall, tied in a loose knot.

Here, I say. It's Golden Square and a group of men drink from brown paper bags. *I saw her sitting on one of the plinths last week.*

What was she wearing? Don't tell me, the pink dress? He is sure it was. *The one with the beaded trim?* He demonstrates how it lined the hem of the skirt.

Trees touch tips overhead. It wasn't the pink dress; it was blue. But I don't tell him. It's his memory too.

Yes, I say. *The pink one. Her feet were bare with dirt on the soles.*

One bed overflows with yellow daffodils and waves of leaping squirrels.

It looks like a cartoon, I say.

Where?

There. But he can't see what I mean. He thinks I'm pointing to the elderly couple, the ones taking tiny sparrow steps to the entrance. The man wears a straw hat, a waistcoat, links his arm in hers. My dad frowns.

A flock of women with wide mouths and eyelashes like feathers stand on Lexington Street, arms and legs in constant motion.

After you, I say to my dad and watch the back of his head as he passes. White hair, flaccid earlobes.

We pause on a corner.

Here as well, I say, gesturing. She had a sleeveless top on, baring her yoghurty arms. I tell my dad she was pushing a bike.

My father steps over a broken road sign. He consults his map.

I say, *Her eyes were red-rimmed.*

Not crying, was she? He replies, tenderly. *Not upset, was she?*

Perhaps it was the light.

There's an overhead passageway between two buildings. Maurice House.

Here too? he asks.

It's his name so he wills there to be a connection. Here's my father looking up into a dark window, and to his left a shop flaunts a series of books on large penises, to his right, a hand-written sign advertises a top-floor beauty. He doesn't see the world as it is. My mother's memory colours his view.

He's right, though. I read my mother's body in the women here too. A girl, bare-breasted walked past me here once. The dark brown nipples were hers. The heavy pull of them, I recognised. *Yes,* I say.

He folds his arms over his chest, seatbelting himself to himself.

A couple kiss on the corner, the wind blows their waist-length hair into combined silken disarray.

My father says, *I worry I made her ordinary. When I met her, she was astonishing.*

Dad, I say. *Don't.* But concerns are his own.

In the evening, we share a pizza and meet a man who once thought he was William Blake.

He says, *I threaded paper angels through my shirt buttons.* He's leaning against the bar, calling over to us.

Marvellous, my dad says, cheeks flushed from his second pint.

The man has blue eyes, clear ones, deep ones. He says, *I wondered about God. I thought about angels.*

Yes, my dad says, suddenly serious.

I had visions, the man says. His scarf is a patterned snake, limply clinging to his neck.

Us too, my dad says. *Us too.* He looks at me, the man, then at his map.

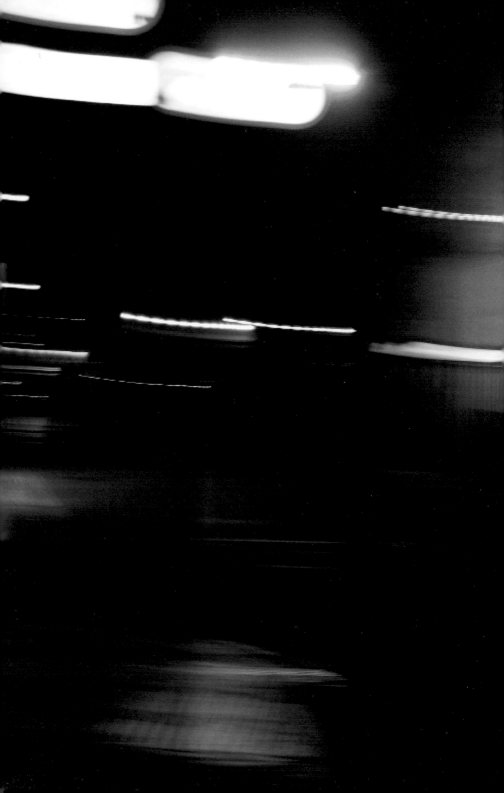

notes on a heart: soho and three short films
david barrett

The Subject in Soho

I live in Soho. Writers prefer not to speak in the first person, but Soho makes a subject of us all. It is a place where you are confronted and forced to respond on a regular basis. You may simply be bumping into your neighbours just like in any other village (and Soho is a village, although its four thousand inhabitants are always outnumbered by visitors – it is a place to be shared, not owned). Or you may be confronted by market traders shouting out to you, or flyer distributors, or marketeers, or chuggers, or pedicab riders, all offering you something. It is the same at night, but with a different crowd: corner pushers and pimps, street clippers and clip-joint girls, the homeless and the junkies.

You cannot drift above this as an impassive viewer. You must speak when spoken to, decide how to react and interact. Jordan Baseman,

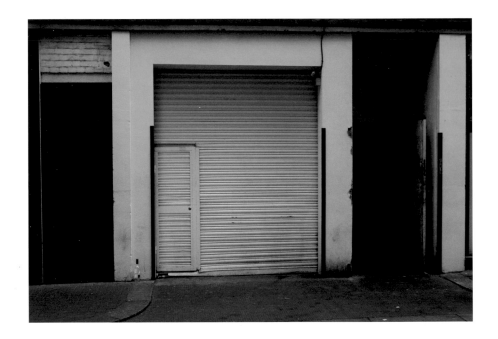

when filming here, was frequently confronted and asked to play back scenes he had just shot even though his 16mm film camera could not give up its footage like a digital camcorder. The filmmaker, like everyone else, was part of the street life rather than a voyeuristic passerby; in Soho we are forced to be an individual subject, dragged into the action as an active participant. So, yes, I live in Soho. Berwick Street, specifically.

One Street in Soho

Berwick Street runs from Europe's über high street, Oxford Street, down to a junction with Peter Street and the choke point of Walker's Court: the seediest crossroads in the West End. This southern section of Berwick Street is a useful indicator of Soho's varied charm.

The short stretch from Broadwick Street south is – among other things – home to: the bedraggled remnants of a once-vibrant street market; highly specialized record shops (the vinyl variety); an audio post-production firm; an independent household goods shop; long-established fabric shops; a betting shop (and its attendant drug dealers who nest like cuckoos in the premises); a small supermarket

(described by a friend from Hackney as the scuzziest in London); a vintage clothing store; what used to be called a 'head shop', selling bongs and seeds (which are sold 'for worshipping only' with a disclaimer: 'it is illegal in Britain and many parts of the world for them to come into contact with earth, air, water and light at the same time, under no circumstances are they sold for that purpose') and which also doubles as a fancy dress costumers; a hairdressers; a 17-storey block of flats; an Islamic faith centre (where on particular holy days crowds spill out into the market, laying prayer blankets among the discarded cabbage leaves and cherries, and praying towards Mecca); a pair of pubs; a Christian fair trade shop; a walk-up brothel; a whole food café; a French bistro; a chip shop; a celebrity-filled French patisserie/Japanese tea house/Chinese dim sum restaurant; and what appears to be a disused travel agents but which in fact houses the food preparation area for the aforementioned Michelin-starred Chinese restaurant. Numbers one to five Berwick Street are currently undergoing redevelopment and this has displaced – but only the short distance to Peter Street – a host of brothels and sex shops, including the rather specialized establishment that is Spankarama.

This eclectic mix, far from unique in Soho, emphasizes that at the heart of the area is a turbulent blend of barely reconcilable impulses: creative, community minded, spiritual, hedonistic, illicit, high-end, low-end and every end in between. Soho is a place to find whatever you want, and a few other things besides.

Capillaries not Arteries
Other than its two grand squares, Soho has always been a jumbled mass of alleys and small courtyards. This is partly a relic of the ancient field boundaries that divided it prior to its first developments in the mid 1600s, but it is also due to the slump into poverty that ensured few grand thoroughfares were built. Although Soho is less than one square mile in size, it still retains over seven miles of streets and alleys, and these tiny capillaries ensure that civil society clots in Soho.

Although Soho was initially developed as part of the move west towards the City of Westminster in the 1650s, the City of London's Great Plague of 1665 and Great Fire of 1666 created a pressing need for homes and ensured that any grand schemes for Soho were soon outpaced by hasty construction work. The nobility that built their manor houses around Soho Square in the 1650s – around 80 titled

residents lived in Soho – soon moved on when the masses arrived; within a century all the nobility had gone, a century later and the area had become slums. By the 1850s the Berwick Street sub district of the St James's parish was one of the most highly populated in the whole of London, with a population density of 432 persons per acre, or one person per 100sqft of land.

At the time, while Karl Marx lived round the corner in Dean Street working on *Das Kapital*, Peter Street's dense housing was described as 'a disgrace to humanity', and nearby Duck Lane a 'hot-bed of disease' and 'nursery of crime'. The little courtyards and alleyways were despised by civil planners, and several new slum-clearing routes were opened up with a clearly stated intention: 'cut the cancer right through the middle'. The alleyways, courtyards and cul-de-sacs choked the urban body, and the Metropolitan Board of Works intended to drive clean new arteries through them (it was an idea that would return in the 20th Century). But although times may change, the previous uses of an area generate its idiosyncratic street patterns, and a unique character evolves from its storied history. Experience is formative of personality.

A Nasty Piece of Stuff
The first of Baseman's films is the most striking: a powerful tale relayed with engaging honesty. While the dramatic drive of the narrative is gripping, it is the protagonist's tragic naivety and heroic restraint that is compelling. It is a cautionary tale for a time – not so long ago – when homosexual acts were utterly proscribed by law. While the story itself is not set in Soho, the narrator, Alan Wakeman, is a well-known Soho resident and active member of the local community. The area named after its hunting past has for some become a refuge.

Baseman links the dramatic urgency of the narrative with accelerated shots of Soho's electric nights, each pause for breath matched to a sudden blackout of the visuals – the imagery cutting away from the frenetic street scenes and plunging into a black void of self-doubt and solitude. The staccato rhythm lends a fit-inducing visual stress to a tale filled with dark adrenalin, hopelessness and, ultimately, a magnificent dignity.

The narrative arc runs from self-loathing, victimhood, acceptance, and concludes with a sense of forgiveness – not for the villain, but

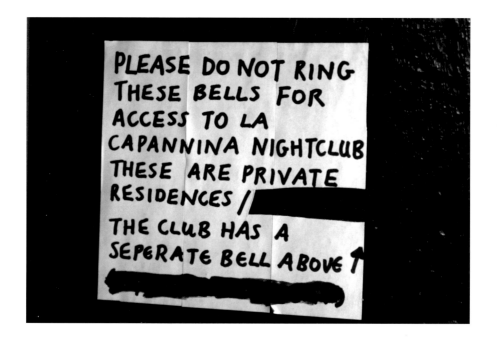

self-forgiveness. Wakeman ultimately rises above the base cruelty of the night predator that he encountered, and the film builds up to a calmness rather than a crescendo. The events described are being revisited long after they happened, and this gives a sense of hope; the victim has not been identified by that role, and instead moved on to forge a life of his own making. It is ultimately a tale not of suffering, but of empowerment.

Tolerating the East End in the West End

A whole slice of Soho's peculiarities can be understood by thinking of it as a piece of the East End within the West End. Many of the characteristics that defined East London can also be found on a smaller scale in Soho, chief among these being a poverty in the 1700s that enabled immigrants who fled their homelands to populate the areas, setting up their own churches, workshops and stores. The Huguenot churches and cloth workshops of Spitalfields are mirrored in Soho, as are the Greek churches, the Italian delicatessens, the Algerian coffee shops, the Jewish markets and, more recently, the Chinese quarters and Islamic centres. While Soho's small size and occasional pockets of prosperity have prevented it from struggling with the corrosive,

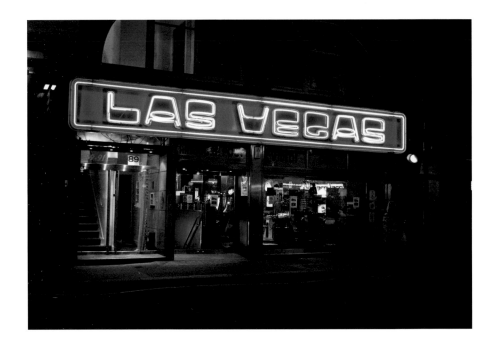

all-consuming poverty that blighted the East End, the multi-ethnic populace and artisanal history is still apparent. Soho, however, also has additional ingredients brought in by the area's proximity to extreme wealth, as well as its long history as a place of fine dining, entertainment and all manner of revelry.

Perhaps only one characteristic can encompass this eclecticism: tolerance. And this is something that – despite myriad minor frictions – Soho excels in. One recent sociological experiment, for example, involved two men walking through central London holding hands, with a researcher following to note if passer-bys turned to look. The result was that the pair drew stares wherever they went, but as soon as they crossed into Soho the glances stopped – tolerance can be measured by the width of a road.

This defining tolerance has ensured that Soho's diversity has been retained – even encouraged – and has sustained it as a place of vibrant contradictions: the very antithesis of the ordered and zoned monocultures that the planners dreamed of. Soho's inclusivity allowed the sex industry to operate, and it had a foothold here long before its

well-documented boom during the years of gangster control and police corruption in the 1960s; it should not be forgotten that Casanova was prowling Soho way back in the 1700s.

Dark is the Night

Baseman's second film has a metaphorical title. The night is not actually dark in Soho; it glows with electrically excited elements. Neon, mercury, argon, sodium, xenon, sulphur, gallium arsenide. At the approximate geographical centre of Soho, at the heart of the capital's heart, lies the district's most photographed scene, Walker's Court – an alleyway dominated by the sex industry. Yet this alley is the most brightly illuminated street in the area, filled with neon signs and arc lights. This luminescence draws visitors, and where there are visitors so there are predators. So the street is, after all, like the night: dark.

Baseman uses a stop-motion technique to film the late-night-early-morning streets, giving the footage an old-fashioned feel, like that of a hand-cranked camera or flipbook viewer. There is a magical quality to his bleak imagery, a wondrous sense of half-movement that reminds us of the effect that so captivated early cinema audiences: life breathed into frozen moments.

There are very few figures in these deserted scenes – the result of months of selective filming and editing – as if people move too fast for this pensive technology (Soho does not empty at night; more pedestrians pass Peter Street in the small hours of the morning than the afternoon.) We see doorways, neon lights, unfolded cardboard boxes for street sleeping. Wet pavements blush through a range of reflected colours under the Piccadilly lights, the alchemical glamour of the night turning the base into the beautiful.

Lucy Browne embodies – in an overt and literal fashion – the contradictions of Soho life. Since Soho is London's playground, where the capital unleashes its desires and fantasies, so by extension Browne reveals the strong currents of complexity that flow through the broader populace beyond Soho's inhabitants. These irrational desires run under the day-to-day surface that the city usually displays; a seam of flammable oil within the stratified bedrock of the human psyche – the most potent energy is always the most deeply buried.

Browne's meandering monologue reveals snapshots of a fractured life

story that, like a cult B-movie script, sees an unfulfilling workaday existence traded for the exotic life of a sought-after transsexual prostitute and drag queen hostess, with multiple wives and children dotting that trajectory like anomalous results in an experiment. In among the discussions of other people's sexual fantasies and surging desires, which are dealt with matter-of-factly like the true professional that Browne is, are hints at the narrator's own peculiar quirks and irrationalities. For example, her rule against servicing French men because of their perceived lack of gratitude for the British and American servicemen who lost their lives liberating France during World War II, and because of the fact that French farmers often go on strike. It's a moment of prosaic silliness, an absurd foible indulged, and it sends a gush of giggles bubbling forth from Browne. She knows this logic doesn't work when stated out loud, held up for inspection in the light of day. This is the revealing nugget, the Freudian slip that fractures Browne's façade, bringing the professional who deals in the irrational to a point of her own irrationality, and so we are reminded again of the nether world of the psyche (rather than the nether regions of the body) that Browne's trade actually relies upon.

Grey Area
The illicit, semi-legal and transgressive all find a home in Soho. The most visible manifestations of this are the brothels, the sex shops and clip joints. But even minor transgressions, those that operate in the grey area of legal loopholes, seem to be drawn to Soho. Whether it is guerrilla advertising written on pavements (a patch of path cleaned via a stencil so that a logo can be discerned) or the semi-legal pedicabs that swarm the streets at night, there is always a loophole to be exploited, an angle to be played, a rule to be bent, twisted and plucked off into an oxbow.

Howard Jacobson, a Soho resident, once wrote about the fact that here even the most mundane of activities can take on an illicit character: "On hundreds of markets throughout the country you are encouraged to believe that what you're buying – the roll of lino, the Limoges china tea-set – has fallen off the back of a lorry; only in Soho do you get the feeling the tomatoes have." It is true; somehow buying a scoop of fruit on a Soho street can feel like a shady activity, one where you might, as Jacobson continues: "ask for bananas sotto voce, in the hope the police aren't watching." But this is only in keeping with long traditions; Berwick Street Market itself began in 1778 as an illegal extension of local shopkeepers' retail space, and remained in

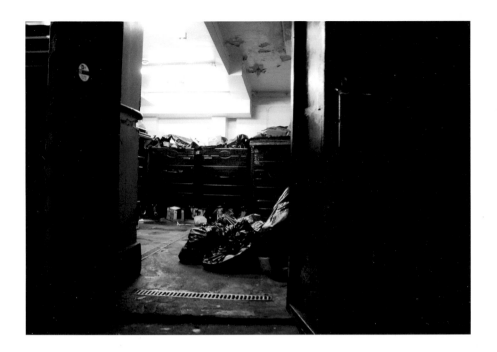

breach of regulations for over a hundred years until it was finally recognized as an official street market in 1892.

The Planner's Will to Order
The area's unruliness draws the authorities' gaze in cycles – one decade officials look the other way, another and the bureaucrats' attention burns holes in it – and many of Soho's problems through the centuries have sprung not from gangsters, drug dealers or n'er do wells, but from the decisions of the authorities.

Soho was under attack again through the 1950s, 60s and 70s; planners wished upon it a futuristic fantasy that would see the old district demolished and replaced by a series of helipad-topped 30-storey high-rises connected by walkways in the sky and an urban motorway charging through Piccadilly Circus at ground level. Soho has always been the kind of place where grand schemes are driven through, clearing that which the authorities deem unwholesome: three of Soho's great thoroughfare-boundaries, Regent Street, Shaftsbury Avenue and Charing Cross Road, were all smashed through existing developments.

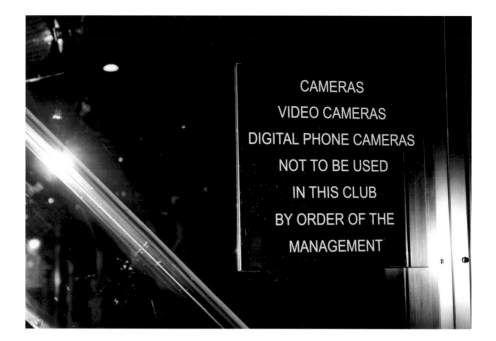

To demonstrate the viability of the modernist fantasy, work began in 1959 on a half-scale tower (Kemp House on Berwick Street, completed in 1962) before an outcry from residents, and the subsequent founding of the Soho Society, forced the cancellation of the master plan. Working on the designs for Kemp House was a junior architect, Alan Wakeman: the subject of Baseman's first film and an active member of the Soho Society. It is fitting that the Kemp House tower itself, this prototype for an abandoned futurist city, would become home to one of the bohemian figures that so defined Soho in the latter part of the 20th Century, the legendary drinker and occasional writer Jeffrey Bernard.

The Dandy Doctrine (A Delightful Illusion)
It is the eyes that give it away. Sebastian Horsley is the only narrator we see in Baseman's three films because he is the only one we need to see. The revelatory openness of Wakeman and the frank, defiantly unguarded comments of Browne reassure us that we are not being led up the garden path. Horsley, however, is a self-confessed dandy, a knowing construct, and Baseman gives him the rope he needs.

Despite theatrical pleas to be shown in a good light, Baseman shows Horsley the mercy that we know he craves: precisely none, like a Warhol *Screen Test*. And for all his plays at archness, aloofness and camp claims to grandiose failure, it is the grasping hesitancy and sense of doom that we read in his eyes that are the convincing signs that he is a genuine character. He works so hard in his performance, but it is only when the show crumbles that we actually believe him, or rather believe in him.

That most famous of Soho's dandies, Oscar Wilde (a local restaurant features a Wildean witticism on its menu, not because of literary pretensions but because he said it while eating there), is the model for Horsley's love of aphorisms and loudly stated philosophies, but unlike Wilde, Horsley need not declare his genius. Baseman shows this by editing Horsley's quips together to reveal their pre-scripted, rote origins – a fact that Horsley readily makes defeatist gags about. Horsley's attempts at his own *Phrases and Philosophies for the Use of the Young* may be witty and illuminating, but they are out of place – or, rather, out of time. Wilde's published list of quips had serious bite because it turned upside down the Victorian values of the day, and yet it used, to spectacular effect, literary art – the height of cultural expression. As the academic Jonathan Dollimore put it, Wilde's greatest transgression was to be an outlaw who turned up as an in-law, and thus Victorian society could neither laugh him off nor ignore him. A century later and Postmodernism would repeat Wilde's trick of gaining power through an inversion of values, but this time by celebrating a confused, contradictory dumbness: its heraldic list of one-liners would be Jenny Holzer's *Truisms*.

Now, years after Postmodernism's hyper playfulness has been deadened by the booming sound of two towers hitting the ground, the 'nothing really matters' argument feels like a front, and that goes for Horsley as well as Holzer (whose recent work is overtly political and purposeful). Not only has the shock of Wilde's inversions been diluted by Postmodernism, so this brand of theatrical dandyism seems disconnected; an indulgence at a time when the West has had a stomachful of its own indulgences. Luckily for Horsley, he can't really pull it off anyway, and the rather tragic sense of emptiness that Baseman captures (in contrast to the stylised and showy photographs of Horsley that the camera spots around his home) ensures that he is revealed as a convincing character of our time: someone searching for a sense of purpose or completeness and finding that the pleasures

of western excess are simply not up to it. Having done it all and found that it is still not enough, he is evidently still reaching out – still searching – and the hollowness he claims to champion clearly does not bring a sense of liberation to the soul. You can see it in the eyes.

A Queen's Rules

On Ramillies Place, sharing a street with The Photographers' Gallery, there stands an old cell preserved within the Court House Hotel, formerly the Marlborough Street Court House. It was in this cell that the Marquess of Queensbury – an upper-class thug whose name is remembered for codifying boxing – was held when Wilde fatefully called him to account for slandering him as a sodomite. Infamously, the case swung full circle and it was Wilde who was found guilty and eventually sentenced at the Old Bailey to two year's hard labour in Reading Gaol – effectively a death sentence at the time. While Soho couldn't save Wilde, despite briefly taking his oppressor's freedom, we learn from these events that Wilde refused to turn a blind eye to Queensbury's abuse; he even refused to flee the country when it became apparent that he would be arrested and tried for gross indecency. For all his dandyish insistence on the primacy of aesthetics and his revelling in notoriety, Wilde would not allow a thug to cow him because here was a question of social justice that mattered.

Baseman's films reveal what matters. They often rely on a sense of conflict, either internal or external, and through this allow us to empathise with each character, however exaggerated or extreme their personalities may seem. Yet for all that empathy, they also remind us of differences, and these films show us that differences don't have to be a secret in Soho – quite the reverse, they are to be celebrated. Baseman's three films – this oral history of sex – is emblematic of the bitter cruelties, tender perversions and vulnerable humanity of a wider group of folk, beyond these three subjects, beyond Soho, beyond London.

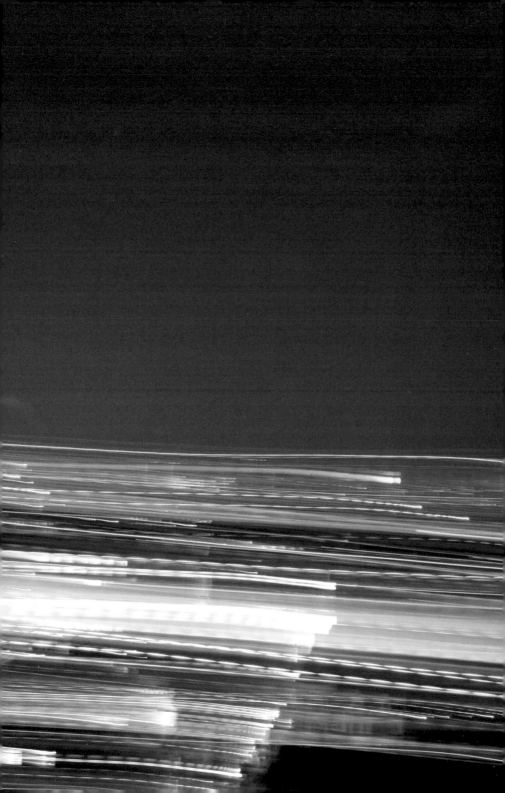

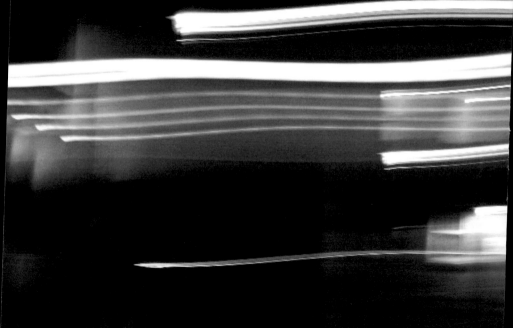

dark is the night

I neither want to be a man and I neither want to be a woman. But in my profession I have to look very feminine. But that is not how I want to be.

Most transsexuals are very feminine and they – because they want to be very feminine and look very feminine: that makes them very unhappy. So that if you can sort of, like, draw sort of something where you can touch both, both your male side and your female side and live your life… then I think for me that has made me feel more happier. Rather than going one way or another way.

I look fairly feminine, but I base myself on being like a tomboy.

I like the look of a woman. But I don't want to be a woman. But then I don't want to be a man.

I understand a women's touch. From being married a few times. And having relationships with women.

Men don't necessarily get that feminine response that they feel that they should get with their partner. So they come to see me and they get that special touch. 'Cause unless you actually date a woman you don't know how a woman's touch is, whereas a transsexual who has never dated a woman: how would they know what a woman's touch is?

I just thought to myself: 'I wonder if I could do this?' I just wanted to see a more interesting part of society. And also having an ordinary job, you have to get up too early in the morning. Whereas on this job you can start when you want to start.

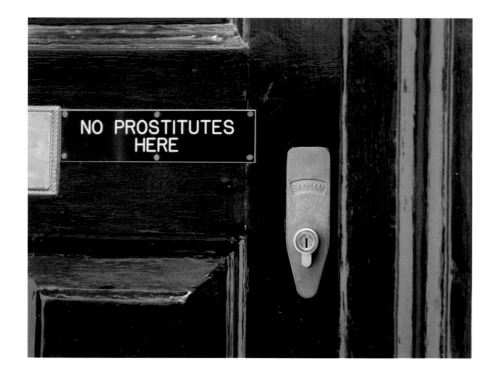

If someone close to you dies, instead of bursting out crying you just basically put it to the back of the wardrobe. And carry on. Bit like this job. Someone comes in, you don't like 'em. They're smelly. They're ugly. You just switch off. You go through your little routine of your introduction and everything and your little sort of show that you have to put on. And you don't think about the person as a person. You just do what you have got to do and get rid of the person. Make them feel happy and warm and then obviously give them a good service. They go - you've got your money. And you move onto the next one.

Some people are very nice and some people are fucking horrible. So obviously… but you've got to treat everybody the same.

Guys come and show me their families, their families of their children, their wives. And they want me to piss in their mouths. Or they want me to come around and eat my shit. You know what I mean? I mean really speaking, are all men the same? We're all doing clients every day of the week. And we are all mostly doing men. It's strange, but if women were the same, well, we would have an equal amount of women, but we hardly get any women. We mostly get men. So never trust a man.

I think that to do this job everybody should have a check once a month so, obviously, 'cause there are lots of girls, obviously, who do lots of sex without condoms and

obviously that is making the population more immune to getting uncurable diseases, whereas if it was managed better there wouldn't be that problem. Secondly, everybody could make money out of this.

And also it is not negative. People always think because you are a prostitute, like, it's really negative and you are like... and whenever you see it on the telly it is – what? We're all into crack? And we are all down-and-outs? Well, as it goes, most of us eat in really cool restaurants where the bills come up to more than what most people make in a week. We have a pretty good lifestyle. We live in pretty good accommodation. Well, it's a big lie isn't it? There is nothing wrong with this job, actually, at all. It's just that people want to stamp it out and suppress us. For what reason? What is the reason? I don't understand it myself.

It is just so false. And another sad thing is, like, well - this is obviously for working girls, like I say, that for transsexuals who are doing this job and for gay men who are doing this job - your clients come to see you and they say that: "I'm not gay. I'm not bi." But here they are and they are visiting me. And like, it's like everybody is living a lie. They are not true to themselves are they?

If I get into a cab and the cabdriver says: "Oh, and what do you do for a living?" I just come straight out with it. And just tell him I am a prostitute. 'Cause I don't actually think that there is anything wrong with being a prostitute. Everybody is a prostitute. Everybody who works in this country is a prostitute. You're selling your body for your work. So a bricklayer who goes to work and lays bricks? He is selling his hands. To lay bricks. Well is that not a prostitute? Everybody in one way is a prostitute. It's just that I am just selling my body.

I don't like London at all. All foreigners in my country and it's not my country anymore. It's a good place to make money and it's very cultured in the sense of, like, there's lots of different nationalities and that, but there's also a negative side. Crime has gone out of the window. And there's, like, lots of gangs and there's lots of Mafia. And obviously doing this job, you know, like, you see lots of things about the underworld which, like, an ordinary person would not ordinarily see.

London has become a really violent place.

I think that everybody has got a little secret when it comes to sex. And I think that's because ordinary sex: we can get it all the time. But sometimes we crave for something different, something perverted. So, if we can do it, it kind of, releases the pressure. If we're gay we have got that side. If we're straight we have got that ordinary sex which is good. But there is always a little something which, oooh, you would love to do. Like guys for instance, would always like to have two women in a bed. You know what I mean? Two men would always like to have two cocks in their mouths. You know what I mean? So that at the end of the day it's something that isn't ordinary, but at the end of the day it's kind of sick, really.

When someone comes to see me I'm trusting that they're going to treat me right. But sometimes you have the most ugly experiences. Like life-threatening experiences. So,

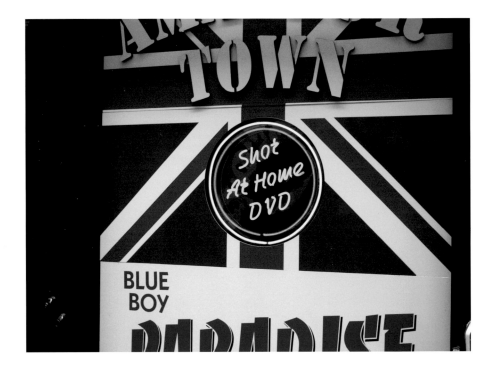

I'm offering a service. Someone comes to see me. And I'm putting my trust that they are going to pay me my money. And we're going to have a nice time. And you're going to go about your business, and I'm going to go about mine. But it doesn't always work out like that. Sometimes you are in life-threatening situations. I've only ever had one life-threatening experience in all this time. But the person who gave me a life-threatening experience then had a life-threatening experience put his way. In this profession you meet lots of different people. And some people you meet are life-threatening people. But you can use those to your advantage. 'Cause you can phone them.

There is a magazine that comes out and it is called *Ugly Mugs*. It's a magazine which basically comes from an organisation which caters and looks after prostitutes. Who, like, come around and make sure that you are OK. For instance, they give you condoms and they give you a little booklet which comes out once every three months - of people who have come to different flats threatening girls.

I don't do black guys, not because I am prejudiced, I just don't do black guys because in a magazine which has got 30 pages you might have 28 pages which are all black. So for me - I don't do black guys. Secondly, I don't do Indian guys because they are the people who mostly want sex without a condom and they are mostly into scat, which is eating shit. And that mostly comes from the Indian side of people. So obviously I don't do them sort of things. So if someone phones me up and they sound Indian and I ask

them where they are from. I always ask: "Are you white, Asian, black, blah, blah, blah, nationalities…" and if they say a nationality which I don't do, then I just say: "Sorry I'm not interested." So I don't do black guys and I don't do Asian guys and I don't do French guys. I don't do French because… well… General de Gaulle said that, basically, the French liberated France - whereas actually it was the British and the Americans that liberated France and we lost a lot of men. And also they kill our cows and throw our milk on the floor because they don't like English so, well, I don't do French.

I had reasonably sized breasts to see if I could live with breasts. But really what I want is big breasts. Not because I think that they would make me look more feminine, but they would make me look more outrageous.

I've had lots of silicon work done, like in my arse, and silicon work in my face and lips, but I need cheek implants to make… to give me more cheeks. Because I think my face might look feminine, but it looks a bit gaunt. And I want bigger lips. Not because women have bigger lips, but I really want to get back to doing my drag. Because I used to be… I used to perform. Before I done this job I used to cage dance and I used to work in different clubs and, like, in Ibiza and things and I used to be a really outrageous drag queen.

I need money for the future to build my house and to have money set aside for what I want. For when I get older and for what I want for my children. Because I have children. From lots of different relationships. And also I want enough money so I can go back as doing like the last two years of this part of this chapter of my life. About visiting all the major festivals around the planet. And doing my drag that one last time. And then just go back to having, like, small breasts. Or no breasts. And just living in my little place, wherever I've got my thing. But obviously my ambition within the next year or two years is to continue saving what I'm saving and then next year, if my goal continues to go the way it's going, is to go and finish off with the last little bits of my surgery, to be able to really give up doing this job, and then having a more enjoyable life, where I haven't got to be having sex for money and I can just tour around doing my drag. And being really outrageous.

I'm not a transsexual who was born thinking I was in the wrong body. I'm a transsexual coming from a drag side of life. Not a feminine side of drag, coming from an outrageous side of drag. Like, Mohicans, and coming from that last end of the Punk era. I didn't want to go and get massive sort of breasts. Well, I mean, they are still pretty big. Not, not really big. And I just wanted to see what it would be like. So, I've gone from a flat-chested man, to someone who has got, like, double D breasts - which is quite big. I've learnt to live with it. I haven't got a problem of living with it, but it does create certain problems. Like one problem is running for the bus. That is a really funny experience. 'Cause you have got these two things which are not actually, they are attached to your body, but they don't feel like they are. It is like you're wearing a pair of pyjamas but you have got the buttons digging in you – it is that sort of feeling. But you've got two of them.

The experience of having breasts is… it really identifies you. Which I didn't realise, like, when you walk down the street. I dress very like a lesbian, in the way I dress. And

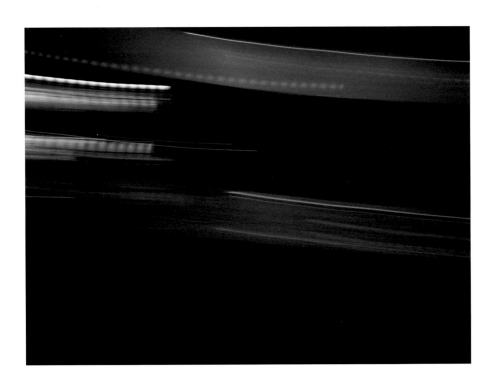

I have people saying: "Oh look, there is a dyke", or other times I have people saying to me: "Oh there's a transsexual." But obviously you can't just take your breasts out. So the difference when I was drag obviously, I had breast forms I could take them out and just get on with my life and just walk around. I would have an unusual hairstyle but no one would identify you as being either transsexual or whatever. But when you have got breasts they identify you as to wanting to be a woman.

Some of my transsexual friends have had breasts and then found that it's too much. They are now looking too much like a woman. And it's like an overload. They don't want the breasts. The bottom line is that breasts don't make you a woman. It's how you feel inside.

Our body is a canvas. It's a blank canvas. It's like you have to be a little bit creative. To make you feel happy in your life. And, like, we have got the technology to do it. And if you dig out the good surgeons and everything you can get a good look. We have got other things available to us like silicon and that, and it means that you have to travel far over the world to get it done, as obviously in this country it is illegal. But at the same time you get good shapes out of silicon. I haven't got a problem with having a big arse. It's just… I don't know… it's OK having a big arse, 'cause women have got good shaped arses. So as I get older I suppose, to even it out a bit, I need to eat a bit more. So then I would have a fat body and a big arse, as at the moment I have got a thin body and a big arse. So that kind of, like, makes it look a bit more feminine.

You have to sit down and talk to a person before you really know a person. And just because they might have pink hair or they might have a disability that doesn't mean to say that they are a bad person. So that's one important thing about life: never judge a book by its cover. And never judge people because they might look gay, they might not be gay. Or if someone is transsexual they might not necessarily like men just because they are transsexual. They might still have a heterosexual life. Whereas lots of people just assume that because you are transsexual you have to be gay. But that is not necessarily the case. I learnt a lot about, for instance, about looking at a person and judging a person. I think that is very negative. And I try to adopt that attitude with my children. Because although I do this job and I predominantly see men, I have actually been married four times and I have got four kids by four different women. And I always try to teach my children that because I am transsexual that isn't negative. Because that person might be black that isn't negative. Because that person is kissing in the street, two men, that isn't negative.

A cousin of mine was quite a famous drag queen in London. He had a relationship with a guy and they were going to New York to live, and he said to me: "Why don't you come to our going away party?" He said: "You're always sitting in every night, you're married…" I was married, I had kids. I go to work seven days a week. "You're so boring, you don't do nothing. And you're always saying you want to do something. Why don't you make something and come to my going-away party?" So I thought about it and I thought: 'Yeah fuck it, why don't I do something really crazy for once?' So I made this really unusual outfit out of this stuff that you wrap packaging in and it's got pops: pop-a-wrap. I made this really outrageous pop-a-wrap outfit. And I went out and I bought these big boots but with, like, 8-inch stilettos and like 6-inch platforms from Camden. And I shaved off my eyebrows and I put false eyebrows on. And then I used coat hangers for hair. And I joined all the coat hangers together so that it was like a big hat on top of my head, and I went to my cousin's going-away party. And obviously no one recognised me. 'Cause no one seen me anyway but no one would've recognised me. They all thought I had come from America, 'cause they would never see anything like this in England: that person is, like, just totally outrageous. From that day that is when my life changed. I just… I didn't want to be married anymore. I didn't want to have kids. I didn't want to go to work. And sit in some stupid drawing room, and all that. I just wanted to get out there and everything I was looking at I was, like, thinking: 'Yeah, I could make that.' I was looking at really stupid things and thinking: 'I could make that into an outfit, I could make something out of that.' My life just completely changed from that day. From that day was probably the start of who I am today: that's when that was the new me. But before that I was just going to work sitting in the drawing room all day seven days a week, sitting at my fucking computer doing nothing. Having a boring life. Sitting at home watching the telly every night. And I just went from that day of when I started, I went out and my life completely changed.

If you want to live in London and you want to live a good lifestyle you have got to make decent wedge. Otherwise how can you afford to live? It was either to carry on doing my old job… or to get into a job where you have got the potential of making good money at the end of the day. The only problem is now, obviously, I don't do a lot of drag. 'Cause I never really have a lot of time to do a lot of drag. 'Cause I am always doing this job. 'Cause I want these bigger boobs. I always want these things. There are

always obstacles that get in the way.

There's always an opportunity for making money and selling sex. I go to Tesco's and pull someone in Tesco's, unwittingly. You can walk anywhere. When you're transsexual and people see that you're transsexual, there's always someone out there who wants to suck your cock for fifty quid or a hundred quid or something. So you've always got the opportunity of making money. So if I've got myself a good base and I've got money in my account... and I got the surgery done - what I need to get my surgery done – then I can basically give up doing this: and go!

I gave up my job and I basically had a year of thinking about: 'Ooh, shall I go and get breasts?' So I had a year out. I went and got breasts and then I basically bummed around for about another six months, thinking: 'Well, I wonder what I can do?' And then one day I just thought to myself: 'Well I think I will put an ad in the newspaper, and see what kind of response I got.' And I didn't pick up the phone at all. I had loads of people call me. I had about 100 people call me in one day. And I didn't bother to pick up the phone at all. And then one day I just thought to myself: 'Well...' I woke up one morning and I thought to myself: 'Right, the first person who calls this morning I'm going to speak to 'em.' And the first person who called, I spoke to 'em and they came round and I give 'em a hand job. And that is how it went. But before that I had never even touched a cock in my life. Other than my own. But I just switched off. I just switched off and I just dealt with what I had to deal with. To see if I could do it. And then once I went past the thing about, ooh touching someone else's cock. I don't know how it escalated but it escalated to a stage where I could quite comfortably say that I was bisexual. 'Cause, I actually... like cock. And I like tits and I like fannies so it has got to the stage now. Before I would never ever say I was gay or I was bi. But now I will openly say I am bi.

Yeah, my kids are well cool. Because they know, at the end of the day, right, that we are both giving each other, like, this really unconditional love. They've got – like for instance – I can't go to their parents evening because I try not to interfere with, like, with their life with their mum and their life that they are living and everyone being naïve. But they know that when they come and see me we go out and we have a fantastic time. We go to Soho, we go to all the bars and they're introduced to a totally different life. And all my children are mixed-race, so they're going to have prejudice anyway. I take them to top-class restaurants. Teach them good table manners. Introduce 'em to really good quality food. In their life and where they are at now they get junk food. With me they eat very healthy. They eat in good class restaurants. And they get to go to basically all the make-up shops and all the shops that sell unusual clothes. Yeah. Yeah, we have a good old party.

They are at a stage where in probably a few years time they will be able to come out. So I would take them - one of 'em especially - I would take them to the Mardi Gras, Australia. And I wouldn't have any objection to my daughters, for instance, I wouldn't have no objections to them, if, in the future - not to say that they would want to get into what I do, and I would never tell them what I do - but if they ever wanted to become, like, a mistress of, like, working in a chamber, in a dungeon, I'd have no problem with that whatsoever. 'Cause they can make some serious money. And they can have a really

good life. They can really have a much better life than Mr. Jo Bloggs working in an office. And plus they get respect.

If you want a really good life – do something in this profession. Have a look around. You don't necessarily have to sell sex. You could work in a chamber. In a Dom Chamber. Or have your own Dom Chamber. I mean I know like dominatrix people who advertise on the Internet. They fly all over the world. Doing domination. To men. All over the world. And they charge good money. They get like between 5 and 10 thousand. To go and fly to someone's house in Zurich. And to have a weekend or a night or whatever with them. And fly all the way back again. Well I mean that is pretty cool isn't it? Wish I could do that.

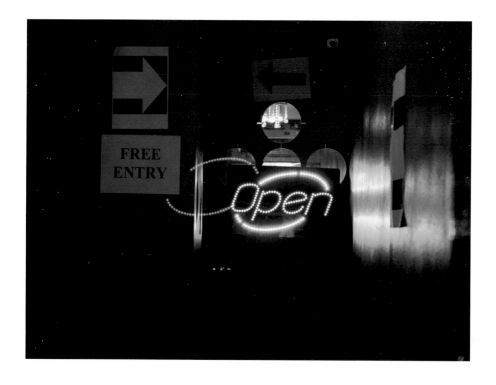

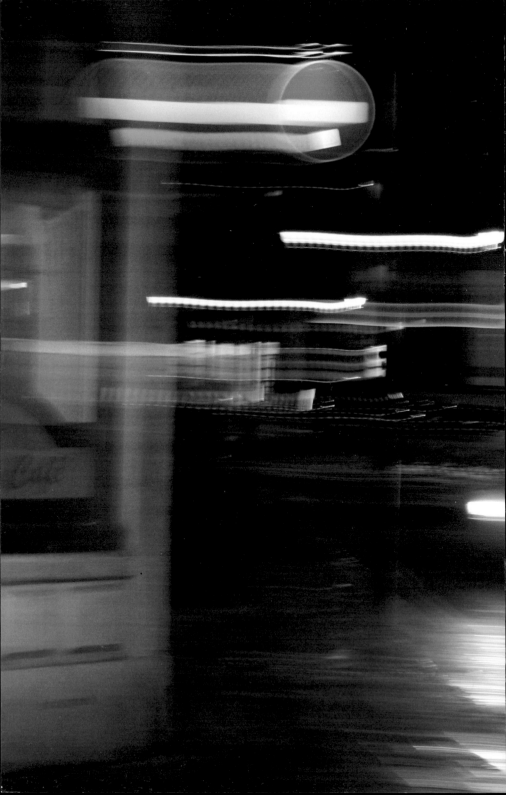

nasty piece of stuff

I was working as an architect. I spent the first years of my, the first eight years of my working life as an architect and I was, as usual, doing a rush job that involved staying working all night. So I was in the office on my own working for hours and hours and I had just had enough. My eyes were shutting down, I was tired and I thought: 'I must go for a walk.' I had no intention of anything. I did not even know what cottaging was until I joined Gay Liberation Front. That was news to me that guys did that. I had never done it. I have never done it. I can't see the interest in having sex with a stranger. But anyway, so I went for a walk down the Kings Road and I walked quite a long way down and I walked back, and I was beginning to think: 'Well, OK, I can do another hours work, but then I really have to pack it in.' And as I was walking past the windows of Peter Jones I walked past this very attractive man. And I stopped and looked back. And he had stopped and looked back! And I didn't know what to do. It was the first time that it had ever happened. I had quite often looked back when I had seen someone I had really fancied but nothing ever happened. So then he pretended to look in the window. So I pretended to look in the window. So then he gradually moved nearer to me. This is what it was like before Gay Liberation Front. And when he got close enough he said out of the corner of his mouth: "Where do you live?" - literally like that. It's preposterous. And I said: "Bayswater." And he said: "Too far." And I thought: 'Good heavens, the first time in my life there is a chance and he says it's too far!' And I said: "We could take a taxi." and he said: "Alright. If you pay."

So we started walking up Kings Road to Sloane Square and then up Sloane Street. And as we were walking up Sloane Street there was an entrance to a church there, with a dark doorway, and he suddenly grabbed me, pulled me into the doorway and kissed me – and that was the first kiss of my entire life. And then we – I was scared, I was scared, I mean if a Policeman had walked by, that was it: we were both in prison. So I was scared, but then at the same time I was excited. So then we carried on walking up Sloane Street. And after a bit he said: "Oh there's no taxi going to come, it's too far and I'm going home." He didn't invite me to his home. I would have been prepared to go. And luckily at that moment a taxi came.

So we got in the taxi and we went to my little bedsit. And when we got into the room he wanted to do one thing and one thing only. And he wasn't going to take no for an answer. And basically he raped me. I didn't think of it as rape at the time. I had no experience of sex. So this is what happens. He fucked me. And it hurt! And it was horrible. And I hated it. I look back and I think why didn't I just kill myself? I mean, what is life? You have waited so many years and it's hell. Then as he was leaving I said: "Are you going to give me your name and address?" And he said: "Yes, I suppose so." I mean, when I look back, I think 'Why did I want his name and address?' And anyway, he gave me a false name and a false address. And the reason I discovered all that is three days later I had gonorrhoea. Ha! My first sexual experience in my life. It's horrible, I was raped. I did say: "No it hurts stop! Stop!" I think that constitutes rape. He did not stop, he did what he wanted. And he gave me gonorrhoea. And then I had to go to the special clinic and the doctor at the special clinic said: "I don't know why we should treat you people." I had to lie and pretend it was with a prostitute. And then I said I had met her in the street and I did not know her name. I used the word 'her'. I mean you risked prison. You know? I mean, when I look back, life was hell. People now have no idea how easy these things are. So anyway I was cured of gonorrhoea with penicillin. The contact person said: "You must tell us who you got this from." And I said: "I don't know her name." I felt totally dishonest and untruthful saying 'her' but I didn't feel I had a choice. But I think I can find her.

I didn't know if I could but I thought: 'I am sure he lives in off the Kings Road somewhere.' So, anyway, a year went by. And I had forgotten all about it and I was walking down the Kings Road, still working as an architect in that same office. I was walking down the Kings Road, and I saw him! And I marched straight up to him and I said: "You gave me gonorrhoea." And he said: "No! No! I couldn't have. I haven't got anything." And I said: "Well I happen to know it couldn't have been anyone else." And he said: "You mean you weren't just saying that? That I really was your first?" "Yes I wasn't just saying that." Anyway I have no idea what he did – I have never seen him again. He was French, his name was Giles something. He was a hairdresser. Nasty piece of stuff.

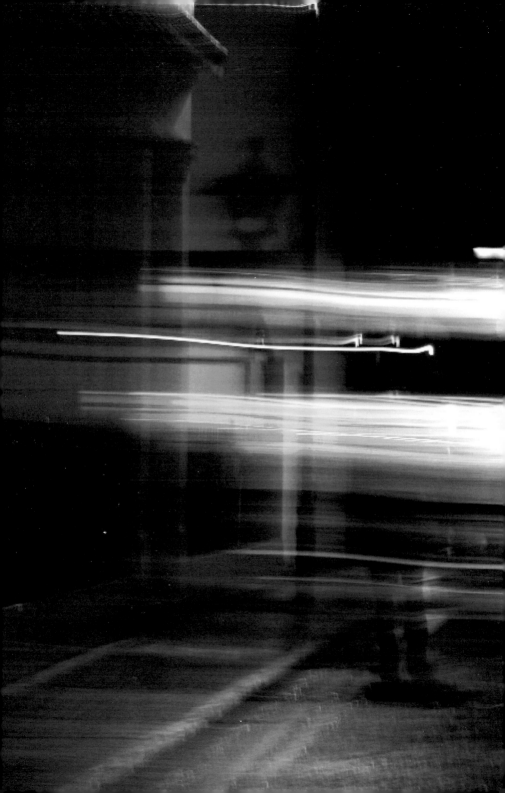

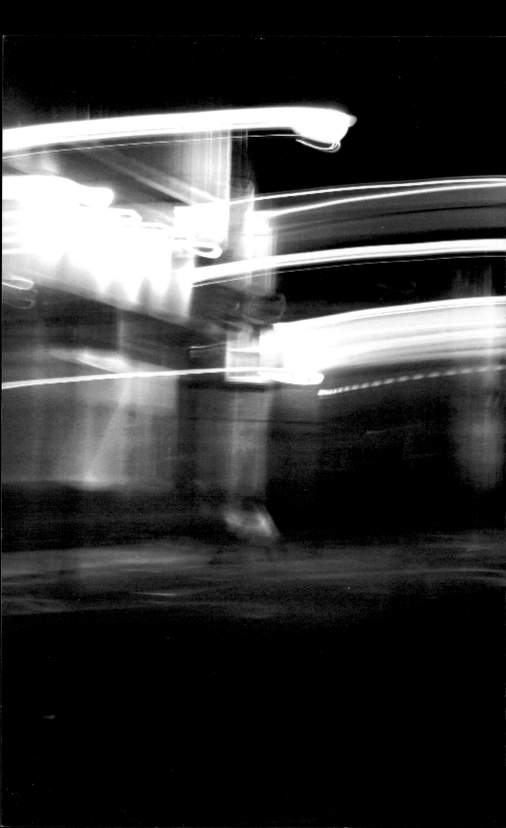

the dandy doctrine (a delightful illusion)

And you have these foul thoughts that just won't leave you alone. Anyway, let's not be morbid.

Make me look beautiful wont you? OK darling I am ready for you.

I want what you want. I'm a one trick phoney. I don't know what I am going to do for the rest of my life, have you got any ideas? Maybe I could do what you do, and we could change. OK darling I am all yours. I only want to say the words you want to hear.

Soho, Soho it's off to play we go.

The problem with life is that it's boring isn't it? This is the problem. Do you get bored too? I want to be somebody else.

I've written about Quentin Crisp here – can I read it? "Quentin Crisp is one of the greatest Dandies ever to have lived. *The Naked Civil Servant* has an aching creative heart. It is a book about narcissism and negation, vitality and vulnerability." This is Quentin's words: "In an expanding universe time is on the side of the outcast. Those who once inhabited the suburbs of human contempt find that without changing their address, they eventually live in the metropolis." That's great, isn't it?

Dandyism is a form of self-worship, which dispenses with the need to find happiness from others. Especially women. It kind of rests on a form of nihilistic playfulness. It's really taking up the position of ironic detachment from the world and living it out in scrupulous detail. Contrary to what people will tell you about it, clothes are the least important part of dandyism. It's really a philosophy.

Given that life is absurd, then our response to it really should be to lose oneself in a perpetual orgy of absurdity. Because nothing matters very much, and very little matters at all. It's a kind of way of performing your life. So the dandy makes the joke explicit. I think this is why he gets on people's nerves. And I am acutely aware that I do irritate people. It is probably because I have the airs and graces of a genius, and no talent. The English invented dandyism. The French explained it. But it is quintessentially English. I don't think you could have it anywhere else. And it is a male thing - you can't have a female dandy.

Where we are worth nothing we should want nothing. And adornment is nothing more than a reflection of the soul. I mean, I would say, it is a form of stoicism really and... er... it usually ends in... madness or suicide. I think that's one of the other key attributes of dandyism, is that it oscillates between narcissism and neuroses. And if you look at the dandy, they usually end in ruin, you know?

The dandy recognises that, given that all character is... er... is manufactured, then you might as well manufacture an interesting one.

There are two universal truths about human beings, the first is that they are all the same, really, and the second is that they all say they are different. And number two is the result of number

one. And so of course the dandy doctrine, well it's a delightful illusion. But it's a form of playfulness, I think. That is one of the things that does irritate English people, is because, as I say, it rests on a form of nihilistic playfulness and… uh… and uh… it's a dance. That is really what it is. It's a dance.

You must be impeccably dressed for the firing squad. And give the order yourself. This is to me the essence of manhood. Turn your misery and your pain and all your humiliation into a form of celebration. Because what is wisdom? Wisdom is the ability to turn disaster into celebration. So I think that is what it is to be a man – is that enough? Is that about right? You can cut the bit off at the end.

English people are bitter and puritanical and spiteful and, er… I know that because I am one of them. Cynicism is the armour of the Romantic. There is no question about that. The reason that dandyism comes from England is because countries that are steeped in the institutions of the past – they erupt in caprice. Without a proper frame you can't have a picture.

I love Soho. Soho… I live in Soho not because it is oh–so fashionable. I live here because nobody belongs here any more than anybody else. It's actually for people without family. It is basically a stomach and a penis. Millions of people all being lonely together. And I like that. It kind of shows society in the process of committing suicide. I love Soho – living in Soho is like coming all the time. If I lived in a beautiful area I would be superfluous but in an ugly area I am a narcotic. So there.

And I mean, you know, people talk about Soho being dangerous and all the rest of it and, I mean, it's not. Outside of the murders, I mean, it is perfectly safe.

Showing off, if that is what you want to call it, is that the anaesthetic that dulls the pain of mediocrity? Is acceptance the courage of losers? It is easy to say that you are not going to sell out when no one is buying. You know? Does everyone feel fraudulent? Does everybody feel that way?

I am simultaneously one of the most real people you will meet and one of the most artificial people, and I think that this is the point.

Success is not the result of spontaneous combustion. You have to set yourself on fire.

Whichever way you play it you are kind of fucked. This is the thing, you know?

Is that part of the human experience - to feel fraudulent, and that everyone else has somehow got it sorted out?

Well success is a matter of luck isn't it? Ask any failure.

There are artists who want their indifference to public notice to be universally recognized, isn't there? Do you see what I mean? Refusing awards is another way of accepting awards with more noise than is necessary. People that are not vain about their clothes are vain about not being vain about their clothes, you know? This is the appallingness of the human condition. That whichever way you play it you're kind of fucked. You know?

My reputation seems to grow with every failure, you know.

The fact is, is that artifice for me is real; it is only truth that is invented.

Give me the luxuries of life and I will dispense with the necessities.

How do I define failure? Well I don't need to define it – I am it.

I mean you never know whether perseverance is noble or stupid until it's too late. But what else is there to do? This is the thing: I mean you can commit suicide, which I think is absolutely fine, too. That seems to me to be a perfectly legitimate response to existence. But I think you must do it in joy. And this is the thing: unhappiness, of course, is the distance between your talents and your expectations. That is what unhappiness is, you know? And... er... the problem is, is that we tend to want more, don't we? Anybody that produces, or tries to produce anything, is riddled with self-doubt, aren't they?

My last thing on success and failure. This is what I think really: that we are... are... we should aim for that which is not too... uh... I have forgotten what I was going to say... Oh, I know! We should not aim for success. But we should aim to continue to fail, but in good spirits. That is what I would say.

I don't like English middle class girls and, if any of them are watching don't bother to come round to 7 Meard Street, black bell, 'cause you will not get in. I like titled or tarts. English middle class girls fuck like they're riding donkeys. They don't really know how to do it. They fuck because they want to take someone home to mummy or they fuck for careers or they fuck for... presents, but they don't fuck for sport. So I tend to go for whores really. Titled or tarts. I like people that you can't see the bottom of.

I love people. I love strangers. I love strangers because they haven't heard the same tired old lines before, you know?

I'm not one of those people who sits at home interfacing with my home computer all the time,

or spends weeks trying to get a ship into a bottle. People are my pastime.

When I became a male prostitute I wanted to sort of… I wanted to turn myself into a slave and sell myself into freedom. I saw it as a kind of sex rebate, having paid for sex all my life. I thought it would be very interesting to put myself on the other side and to be bought and for my character to be bought. And to be stripped down.

The moment you think you are living authentically you are generally living inauthentically. Authenticity is a very difficult pose to keep up isn't it?

I think it is better to have a solid anchor in artifice than to put out on the troubled seas of truth.

To me artifice and imposture and all those things are very sexy. And all the artists that I have liked have dealt in artifice. And creating that type of thing - I like it, I find it sexy.

I just think that this division of lives into one area, as being seen as superficial and some other area as being somehow spiritual… I mean spirituality to me is the biggest pose of all. I don't really believe in things like that - I think that glamour is a far greater asset than spirituality.

I am suspicious of the whole notion of the kind of inner world somehow being more authentic than the outer world. And that if you… uh… that I just think that it is… urm… what do I think? Urm… I've forgotten what I think… What were we talking about? Spirituality…

Well, how do I perceive myself? Uurgh… incessantly.

I always think: 'Who am I to deny you me?' you know? And particularly with things like my body and stuff. I mean I just take the view that if someone wants my body more than I do then they can have it – you know – I mean what difference does it make to me? I mean that… it is just some awful thing that follows me around wherever I go. My body is merely an insect, crawling around in the cathedral that my mind has built. As I say, it is just a pedestal for my head. I didn't even want a body, you know, I… just… I fail to find… I quite like my head. But I don't really like the rest of it. I find it revolting, you know?

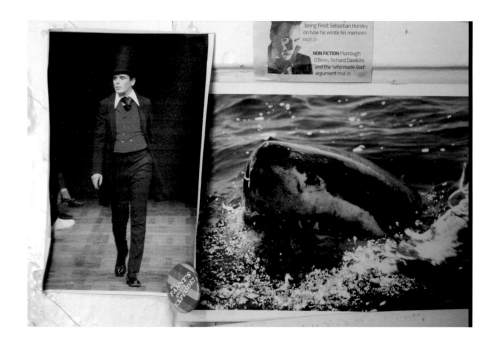

being fired: Sebastian Horsley on how he wrote his memoirs PAGE 20

NON FICTION Murrough O'Brien, Richard Dawkins and the 'who made God' argument PAGE 23

I am not against bitterness. I don't understand why it is one of those… bitterness is a sort of… it is one of the orphans isn't it? A scarlet emotion - no one admits to being bitter. They always, you know - if you say to someone: "What is your character defects?" they say: "Aw, I am a perfectionist." They never say: "I'm fucking petty, bitter, I'm envious, I'm all those things." Envy is basically… it is the world sending out a signal to you that you're being eclipsed, that you are second best, that when the Ark sails you won't be on it.

Now that we have eclipsed the sacred dimension… I mean the church now is just like some old lady, isn't it? Babbling away to herself in a corner, and stinking of piss. And no one is listening to her. That is what has happened to the church. And then of course war has been eclipsed. I mean there is no theatre really for that type of heroism. So all we have got left to believe in is physical, visible worth. Simple survival has become a form of heroism. This is why in this culture now everyone is announcing themselves as drug addicts. Or ex-drug addicts, or they have been buggered by their father. Or whatever.

I mean that everybody that you meet has been sexually abused. I mean I am starting to feel left out, you know? I mean the truth is I must have been a plain boy and my father wasn't interested. I would rather my father buggered me than ignored me. At least that would have been some contact.

More and more people are announcing themselves in this way. It is just... as far as I am concerned, it's pathetic. It is just an alibi. It's, like: "Fuck off", you know? Although I can see the advantage of opening the drug door, for myself - I can see it in terms of my art and my character. I have also opened the drug door for other people [belches]. I have also opened the drug door for other people. And that causes me... I sometimes, yerr... I regret that.

Does Jesus ever get tired of bleeding? I'm sure he does, but the show must go on.

What alternative do we have – you know – what is there? There is just fucking suicide or insanity really isn't there? I like it. I find it... I like the process of living life and then reflecting on it. That's really what art is, isn't it?

OPPERS

afterword

Jordan Baseman's project *Dark is the Night* came about due to shared
organisational aspirations and a desire to collaborate between ArtSway,
based in the New Forest, and The Photographers' Gallery based in London.
ArtSway has a long tradition of commissioning and nurturing lens-based
artists, and those working in a variety of media. The Photographers' Gallery
similarly works with artists developing new projects for exhibitions and
for their educational programme. With a shared sensibility, Directors Brett
Rogers and Mark Segal, realising that ambitious commissions and projects
often require partnership development to provide greater resources,
decided to collaborate on a mutually beneficial new project. This coincided
with a pivotal period in the history of The Photographers' Gallery when,
after 37 years, the gallery relocated from one edge of Soho to another.
This had enormous implications for the organisation and for its audience,
and over this period the gallery has been keen to explore Soho as both a
location and a context, leading to a series of ongoing *Soho Projects*. Soho
also appealed to ArtSway in that it provided the opportunity to work with
an artist examining a uniquely urban place that was once a hunting ground
— echoing the origins of the New Forest where the gallery is located.

In selecting for the commission, ArtSway and The Photographers' Gallery
invited artists working with lens-based media to submit proposals for new
work with Soho as a theme. The brief was intentionally broad to prevent it
from becoming prescriptive. From a strong field of candidates a number of
artists were short-listed, with the panel unanimously making the decision
to select Jordan Baseman. Baseman's methodology and proposed engagement
with a range of participants in his work appealed to the panel, as did
the probing questions in his interviews and his ability to 'get under the
skin' of his subjects. The quality, editing and unique visual approach of
his films also stood out. Throughout the course of the commission Baseman
has been prolific, and those closely involved curatorially have seen his
project radically develop over a short period of time. The final selection
of interviewees for his films has been both rigorous and revealing, with
much footage ending up both metaphorically and literally on the editing
suite floor.

The screening of Baseman's three new films — *Nasty Piece of Stuff*, *Dark
is the Night* and *The Dandy Doctrine (A Delightful Illusion)* — has been
configured differently in each of its public exhibitions at ArtSway, The
Photographers' Gallery, and again when shown at the Venice Biennale as part
of *ArtSway's New Forest Pavilion*. The numerous screening requirements and
their evident success is due in no small part to the power and fluidity of
Baseman's films. At ArtSway the main gallery was transformed into a cinema-
like space, complete with a large couch for the viewer to watch the films
in comfort. The three films were screened throughout the day, allowing the
dedicated visitor the time and inclination to stay and watch each film in
sequence. At The Photographers' Gallery a specially built screening room
has been constructed on the Lower Ground Floor of Ramillies Street, using
an area not usually accessible to the public, where Baseman's three films
will be screened at set times during the day. The Venice manifestation of
Nasty Piece of Stuff is as part of a group exhibition, but within its own

enclosed screening space. It is to be shown without Baseman's other two Soho films, thereby becoming a stand-alone film for a busy and demanding biennale crowd.

This publication should be considered as a fourth element alongside the exhibitions at ArtSway, The Photographers' Gallery and in Venice, and a work in its own right. The intention was to produce a publication containing critical and creative texts — alongside production stills from the films — that were a response to Soho as a place in the same manner as Baseman's films. David Barrett, a current resident of Soho, has produced a witty and informed text that examines Baseman's new films in the context of Soho as a distinctly original, almost defiantly bohemian place to live. Gemma Seltzer was commissioned to write a creative response to Soho. She has provided a story that is not a critique of Baseman's work — rather she has written an honest account of a place with a light touch that is an additional voice to this publication. Also included in this book are transcripts, kept in the interviewees' own words, from each of Baseman's three films. They are included here as a very tangible reproduction of the content of each film, and also echo the artist's working process.

camilla brown is senior curator at the photographers' gallery
peter bonnell is curator of exhibitions and education at artsway

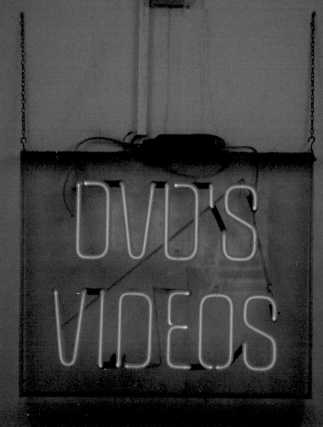

DVD'S
VIDEOS

SPECIAL OFFER
THIS WEEK ONLY
ALL DVDS £15 &
ALL VIDEOS £10

jordan baseman received a BFA from Tyler School of Art, Philadelphia, Pennsylvania and an MA from Goldsmith's College, University of London. Baseman is currently the Reader in Time Based Media at Wimbledon College of Art, University of the Arts, London, and is also a Lecturer at the Royal College of Art Sculpture School. He has a long history of carrying out projects in collaboration with various public institutions. These have included residencies and commissions for: ArtSway, Arts Council England, Papworth Hospital (Heart and Lung Transplant Unit), Cambridge, The Science Museum, London, Dundee Contemporary Arts, Grizedale Arts, London Arts, Camden Arts Centre, The Serpentine Gallery, Collective Gallery Edinburgh, Book Works, National Sculpture Factory (Cork, Ireland), British School at Rome, the Wellcome Trust, London, Monash University, (Melbourne Australia), University of Tasmania, (Hobart, Australia), The Photographers' Gallery London, Matt's Gallery London and The London School of Hygiene and Tropical Medicine. Jordan Baseman has received grants from Arts Council England, the Arts Humanities Research Council, the British Council, the Henry Moore Foundation, the Wellcome Trust, and London Arts Board. Jordan Baseman is represented by Matt's Gallery, London. www.jordanbaseman.co.uk

gemma seltzer's short stories have been published in various online journals including *Lightening Bug* and *Goldfish*. Her work was also part of an anthology entitled *Rogue Symphonies* (Earlyworks Press, 2007). She has collaborated as a writer and editor with several visual artists, including photographer and NESTA Fellow Franklyn Rodgers, on projects relating to identity. In 2008, she completed an MA in Creative and Life Writing at Goldsmiths College and is now working on her first novel. She has a literature development role at Arts Council England, offering support and funding to emerging writers, literary magazines and independent publishers. She also advises on diversity issues. Originally from Bedfordshire, Gemma now lives in South East London and can be contacted on gemma@seltzer.org.uk.

david barrett studied at the Byam Shaw School of Art in 1994 and then completed a fine art MA at the Slade School of Art in 1997. From 1994 he became a regular contributor to *Art Monthly* and *Frieze* magazines, and has since lectured at numerous art schools and public galleries. In 2004 he co-founded a small art publishing company — Royal Jelly Factory — and has published books on the artists Gary Hume, Gavin Turk and Jake & Dinos Chapman. In 2008 he became the Associate Editor of *Art Monthly*. He has lived in Soho since 2001, and in 2004 was part of a group of Soho residents and businesses that organized a community protest against Project Fox: Westminster City Council's plans for the wholesale demolition of Berwick Street market and its surrounding area. The scheme was dropped in 2005.

jordan baseman would like to thank the
following individuals and organisations:

robin klassnik
camilla brown
peter bonnell
mark segal
simon phillips
wendy greenbury
david barrett
lucy head
derek hunt
janet vance
kaye deville
tony curran
sebastian horsley
lucy browne
alan wakeman
marc munden
mark selby
matt scott
corinne felgate
john frankland
rich cramp
len thornton
gemma seltzer
sally o'reilly
steve jones
ashley kurik
daniel
sunset strip club
matt's gallery london
artsway
photographers' gallery london
wimbledon college of art
university of the arts
cuts hair salon
soho film lab
n.o.where
fuji film — poland street
westminster libraries
westminster city archive
fairview elementary school
mrs. siminac
louise clarke
thompson family
baseman family

the photographers' gallery
johanna m. empson
andrew gault
jo healy
sioban ketelaar
janice mclaren
tim mitchell
jo peace
carl richardson
brett rogers
sam trenerry
jason welling

film and video umbrella
steven bode
mike jones

artsway
diane blackbourne
sarah gorman
hannah harvey
anastasia heale
jack lewis
kirsty marijewycz
melinda mccheyne
laura mclean-ferris

very special thanks:
carolyn thompson

The Photographers' Gallery is currently supported by:

Supported by
ARTS COUNCIL ENGLAND

ArtSway is currently supported by:

 Supported by Hampshire County Council New Forest DISTRICT COUNCIL

Supported by
ARTS COUNCIL ENGLAND